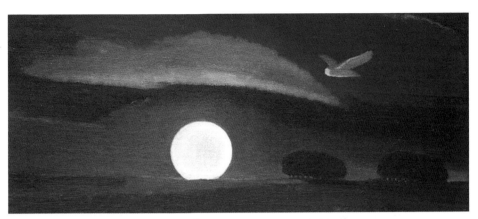
'Full moon at Avebury' (detail) by David Inshaw

Contents

CW00551140

Introduction and History of the Wiltshire Heritage Museum

Bronze Age Gallery.

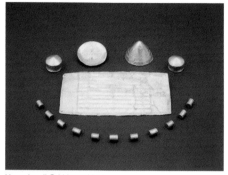

Upton Lovell Gold Assemblage.

The starting point for this publication was the selection of four items from The Wiltshire Heritage Museum, from which four walks could be created. It is hoped that the objects not only highlight the diversity and importance of the Museum's collection, but also that of the North Wessex Downs as a place of outstanding archaeological significance and continued inspiration to both writers and artists.

The Museum together with its Library was originally set up by the Wiltshire Archaeological & Natural History Society, founded in Devizes in 1853. Its current location in Long Street goes back to 1874, originally occupying the Victorian Devizes Grammar School.

Since then it has been extended greatly and is home to a nationally significant collection of items, covering archaeology, recent history, natural history, art and literature, including what are generally considered to be some of the finest Bronze Age finds outside the British Museum. Within the Library can be found many rare and fascinating items such as the 1628 illuminated copy of the Devizes charters,

original Henry Fox-Talbot negatives and photographs, along with the works of famous antiquaries such as William Stukeley and Sir Richard Colt Hoare. The Museum's art collection has around 20,000 items related to Wiltshire and includes works by such artists as David Inshaw, John Piper and Robin Tanner.

For further information please contact:

The Wiltshire Heritage Museum
40-41 Long Street
Devizes SN10 1NS
Tel: 01380 727369

Opening hours:
10am - 5pm Monday - Saturday
12pm - 4pm Sunday

Please contact the Museum for the Library's opening hours.

The North Wessex Downs Area of Outstanding Natural Beauty

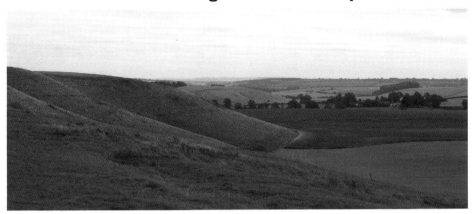

The North Wessex Downs AONB was created in 1972. It is one of forty such areas in England and Wales that now exist as a result of the National Parks and Access to the Countryside Act of 1949. All together they cover around 18% of the most beautiful countryside to be found in England and Wales. The North Wessex Downs area itself covers 1730 square km (668 square miles) and is home to around 125,000 people, mainly centred around the market towns of Marlborough and Hungerford.

This spectacular landscape is essentially one of expansive chalk downlands, but within it can be found a number of different landscapes including wooded plateaux, river valleys and small areas of heathland. Given its diversity it is also home to an array of rare and distinctive flora and fauna much of which can be found within its 66 Sites of Special Scientific Interest. Look out for plants such as the Pasqueflower and early Gentian and the more common yet no less beautiful Greater Knapweed, butterflies such as the Adonis Blue and Silver Skipper or birds such as the Skylark or Yellowhammer.

It is also, of course, an area marked with the impact of thousands of years of human activity and includes the World Heritage Site of Avebury, which also includes the mysterious man-made hill of Silbury. To the south stands the huge linear earthwork of Wansdyke and cutting almost through the heart of the downs is the Ridgeway, generally considered to be Britain's oldest road. Numerous examples of Iron Age hill forts can also be found, such as Martinsell, Barbury and Oldbury all of which offer superb views of the surrounding landscape.

The North Wessex Downs AONB Council of Partners and officers work in partnership with farmers, landowners, businesses, communities and local organisations to conserve and enhance this protected landscape. Their work celebrates the special qualities of the landscape and encourages the long term economic and social viability of the North Wessex Downs.

Greater Knapweed

Four walks - Four objects

Richard Jefferies - The story of my heart

Walk 1: Liddington Hill

The writer Richard Jefferies was born in the hamlet of Coate, now part of the ever expanding town of Swindon, in 1848. Over the course of the next 39 years he went on to write a number of evocative books on the English countryside. Much of his deserved reputation is based on these. His autobiography, 'The Story of my Heart', though is quite unlike any other book that he wrote and most certainly not what you would usually expect from the genre. Whilst many of his earlier books had hinted at his mystical rapport with nature, here it is given full rein as he conveys his sense of the wonder of life, the natural world and the infinite universe in what he called his 'Soul Life'. Many of the ideas contained within the book came about as a direct result of his earlier wanderings through the Wiltshire downland, in particular Liddington Castle and the surrounding area.

Walk 2: Avebury World Heritage Site

David Inshaw is one the finest painters of his generation and is part of the great English Romantic tradition of artists, writers and musicians. Not surprisingly his heroes include Samuel Palmer, Stanley Spencer, Thomas Hardy and Edward Elgar. Born in 1943 in Wednesfield, Staffordshire, he was brought up at Biggin Hill on the North Downs in Kent. When looking for a peaceful backwater to pursue his work he discovered Devizes and immediately fell in love with the surrounding landscape. He recalls days

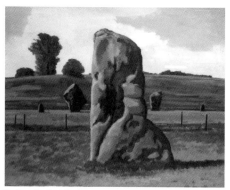
'Avebury ' by David Inshaw

spent working in the studio before heading out to the downs in the evening with nothing but skylarks and huge flocks of lapwings for company. On first viewing, this painting of a Standing Stone at Avebury may have little to do with his seminal works of the seventies such as The Badminton Game, owned by Tate Britain but it still addresses the common themes of his work such as memory, sensuality, stillness and wonder.

Four walks - Four objects

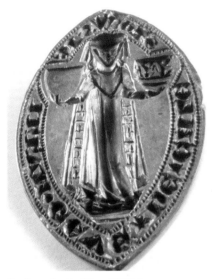

The silver seal matrix of Geve of Calstone

Walk 3: Morgan's Hill

The silver seal matrix of Geve of Calstone, found in 1992 on the site of her manor at Calstone, is one of the museum's treasures. Dating from between 1280 and 1320, it depicts Geve dressed in a wimple and fur-lined cloak. In her right hand she holds the shield of the Wiltshire family of Calston or Calstone into which she had married. The shield in her left hand which should show the arms of her father is blank, perhaps to show that he did not bear arms. However, he is likely to have been a person of status for his daughter to have married into a land-owning family. The inscription around the edge reads 'SIGILLUM GEVE DE CALESTON' or 'the seal of Geve of Calston'. This wonderfully rare object was purchased by the Museum through the MGC/ V&A purchase fund and the Beecroft Bequest.

Walk 4: The Kennet & Avon Canal

This rare and unusual bronze pin was found at Woodborough in 1993. The pin along with other finds in the vicinity suggest that the area is the site of a villa of some importance. The pin has a loop at the top for attachment which is flanked by two birds, possibly doves. Down its shank appears the name LUCIANUS, possibly the name of the man who wore the pin, who may well have been a member of the family who owned the villa. What makes the pin so rare is that of all the many thousands of people who lived in Wiltshire during the Roman period, we know the names of only a handful, generally inscribed upon their personal possessions. The pin's purpose is unknown but it is likely that it was used to fasten an item of clothing.

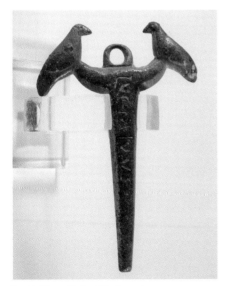

Inscribed Roman Pin from Woodborough

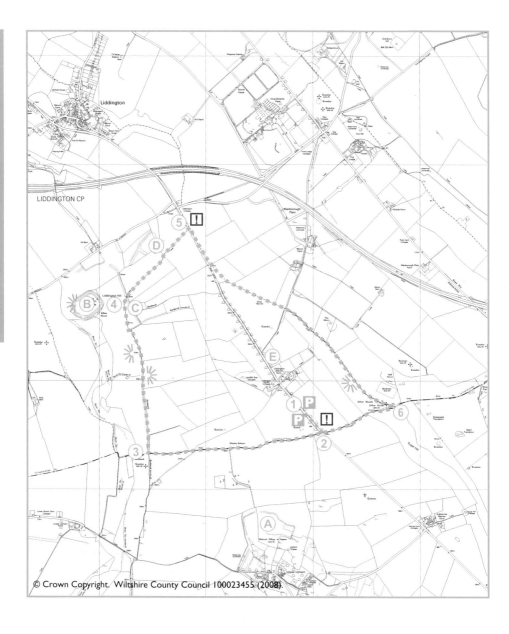

© Crown Copyright. Wiltshire County Council 100023455 (2008).

Liddington Hill: Walk I

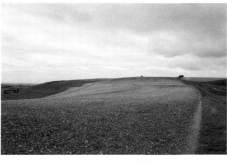

Distance: 4.5 miles

Minimum time: allow at least 2.5 hours

Stiles: 0

Terrain: unmade paths and tracks (can get muddy), one steep descent.

For the start of this walk use the lay-by (1) on the western side of the B4192. Staying on the same side of the road walk briefly **(please take care as the traffic on this road can be very fast)** in the direction of Aldbourne, until you reach the byway at the end of the avenue of trees, signed as the 'Ridgeway route for vehicles'. Turn right and proceed along the track (2) through Shipley bottom. A fine example of an enclosed coombe or short valley, it was described by the writer and poet Edward Thomas (1878-1917) in his biography of Richard Jefferies as 'walled on every side by down and sky'. Thomas, who was born in London to Welsh parents, spent a number of childhood holidays in Wiltshire with his grandmother at Swindon, during which he developed a great affection for the county. His biography of Jefferies is also one of the best introductions to the Marlborough Downs written to date. After a short while, the track begins its gradual ascent towards the main Ridgeway path.

On your left, to the right of the copse on the horizon, once stood the medieval village of Upper Upham (A), which may have been occupied since at least the 1st century AD. The village was also the site of a hunting lodge used by John of Gaunt, the son of Edward III, who owned both Aldbourne Manor and Chase in the 14th Century. As the path continues its ascent it becomes ever more enclosed by hawthorn, a real delight in spring. At the top of the hill, you arrive at the junction with the Ridgeway National Trail (3). Turn right and proceed along the ridge towards Liddington Hill. The path here affords stunning views over Swindon and beyond. It is also likely that this is the path the seemingly forgotten poet Charles Hamilton Sorley (1895-1915) would use when returning to Marlborough College from his visits to his father in Cambridge. Sorley studied at the college between 1908 and 1913 and spent much of his free time on the downs above Marlborough. Although Sorley only wrote 37 poems during his short life, the writer and poet Robert Graves considered him to be one of the three great poets killed during the First World War.

At the field edge continue through the metal gate and stay on the path as it maintains its steady ascent. The Iron Age fort known as Liddington Castle (B) that stands on the western edge of Liddington Hill slowly comes into view on your left. Like Barbury Castle to the west, it stands at the head of the River Og valley, guarding what would have been one of the main routes into Wessex from the north. The fort has also been considered as a contender for the site of Badon Hill, the scene of King Arthur's climatic battle with the advancing Saxons.

Shortly before you reach the next gate, you will pass the remains of an old shepherd's hut on your right (C). Shepherding was, until the early part of the last century, the main agricultural occupation on the downs and W H Hudson's (1841-1922) book 'A Shepherd's Life' is recommended to anyone wishing to find out more.

Shepherd's hut

Once at the gate (4), you can either remain on the main trail or follow the permissive footpath left as signed, to Richard Jefferies' beloved castle, where the writer's view 'was over a broad plain, beautiful with wheat and enclosed by a perfect amphitheatre of green hills'. The view today is still impressive, though quite different from that enjoyed by Jefferies. Unfortunately the noise of the motorway also cuts through the solitude that he would have experienced. A possible solution to this is to carry an MP3 player and enjoy some appropriate music; though not quite solitude, it can certainly add positively to the experience.

You will also find here a memorial to both Jefferies and Alfred Williams (1877-1930). Williams also wrote about Liddington Hill, but is chiefly remembered for his book 'Life in a railway factory' which has been described as the most important work of literature written in Swindon about Swindon. Almost entirely self taught, Williams wrote thirteen books including some fine poetry and an affectionate portrait of Wiltshire life entitled 'Villages of the White Horse'.

Those choosing not to visit the castle should, once through the gate, continue along the Ridgeway National Trail. As it bears right, away from the castle, it passes a small clump of beech trees that crown the hill known as Liddington Folly (D). Clumps such as these are a distinctive feature of the downs and usually date from the 18th or early 19th century. They appear to have been planted for no apparent reason and sometimes, as at Liddington, became known as follies. The path then begins its descent towards the B4192, where you must pass through the gate, before continuing across the road and down several steps set in the field boundary. **This is also the nearest starting point for those arriving by public transport (5).**

At the bottom of the steps turn right and continue walking along the edge of the field. The path soon begins to bear left as it follows the field edge and, after a gentle climb, passes through a field entrance, before making its descent. Keeping the fence line to your right, the path starts to climb once more and you pass through several more field gates as you continue along to the top of the high ridge. The buildings down below belong to Liddington

Warren Farm (E), which takes its name from the rabbit warren that once existed there, one of many in the area that were an important feature of the medieval landscape. At the junction with the Byway on the top of Sugar Hill (6), whose name is probably derived from a 12th century local landowner known as 'Segur', pass through the gate, turn right and begin the steep descent along the track once known as the 'Thieves Way'. Continue through the next gate and on towards the gate that stands adjacent to the main road. Once through, turn right facing the oncoming traffic and walk along the verge before crossing over the B4192 back to the parking area.

For those who started at point (5) cross the road and follow the directions from point (2).

'By the time I had reached the summit, I had entirely forgotten the petty circumstances and annoyances of existence. I felt myself, myself.'

Richard Jefferies from 'The Story of My Heart', 1883.

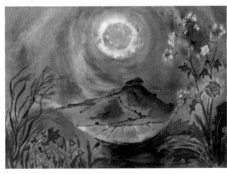

Imaginative Water Colour of Liddington Hill - Jean Muir

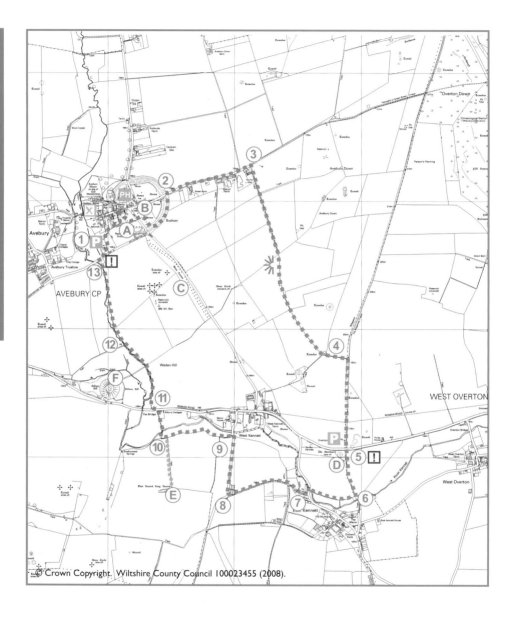

© Crown Copyright. Wiltshire County Council 100023455 (2008).

Avebury World Heritage Site: Walk 2

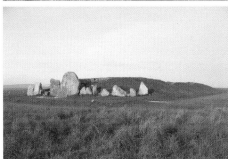

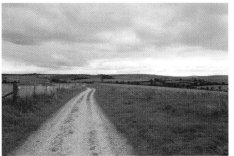

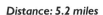

Distance: 5.2 miles

Minimum time: allow at least 3 hours

Stiles: 3

*Terrain: unmade tracks, grassed paths
(can get muddy in places).
Some minor road walking. One steep descent*

Note:

*There is a charge for the car park in
Avebury (Free to National Trust members).
If you wish to avoid this then park at Overton
Hill and follow the route from point (5).*

From the National Trust car park (1) follow the signed path into the village. At the junction with the High Street turn right and then right again through the small field gate. Once through the gate follow the line of stones (A) as they slowly curve to your left. Dating from around 2600BC, the stone circle originally consisted of about 98 stones of which 27 remain. Many of these were carefully re-erected in the 1930s by the millionaire Alexander Keiller (1889-1955),

entailing the destruction of a number of the existing buildings. Much of the rediscovery of Avebury's monuments has been made possible thanks to the work of the 18th century antiquary William Stukeley (1687-1785) who first visited the village in 1719. Over the next five years he produced a number of detailed drawings and plans of the area, which have proved invaluable in piecing the jigsaw back together. At the fence line proceed through the

gate and cross the road, taking great care, and on through the next gate. The standing stone (B) in David Inshaw's painting on page four is the second on your left.

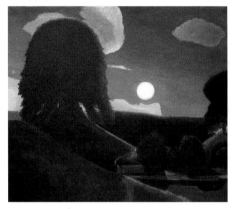

'Alf and the moon at Avebury ' by David Inshaw

From the gate turn right and proceed up on to the bank that surrounds the stones. Stay on the bank as it heads north curving around the village. Upon reaching the end of the bank, pass through the gate on to the road and turn right. You are now on Green Street (2), originally one of the main routes between Bath and Marlborough. Keep going until just past Manor Farm and take the byway on your right marked 'Overton Hill' (3). As it begins its ascent, the West Kennet Avenue (C) comes into view on your right. This double row of stones originally linked the Sanctuary on Overton Hill to the circle at Avebury. Continue uphill towards the clump of beech trees ahead of you. Clumps such as these, which sometimes contain barrows, as on this occasion, are a familiar sight on the Marlborough Downs and are known locally as 'hedgehogs'. Just before the trees

look to your right for Silbury Hill just visible behind Waden Hill. To its left on the horizon it is possible to make out the undulating form of the West Kennet long barrow. Continue onwards to the end of the byway until it meets the Ridgeway. At the junction (4) turn right and enjoy the stunning views as you head south towards Overton Hill. Just before reaching the parking area adjacent to the A4, you will pass a number of round barrows. Dating from the early Bronze Age, they are part of a once much larger linear cemetery.

Upon reaching the junction with the A4 (5), take great care and cross over on to the byway straight ahead of you. To your right is the Sanctuary (D) destroyed in 1724 and then rediscovered in 1930 by the archaeologist Maud Cunnington. This many phased structure was begun around 2600BC and continually revised until at least the early Bronze Age. Today all that can be seen are a number of concrete marker posts. Stay on the track as it descends towards East Kennet. Just before reaching the tree line turn right through the open gate (6). Continue along the field edge, noting Silbury Hill ahead of you, until you reach a directional finger post adjacent to the road. From here turn left and cross over the bridge. Take the next track (7) on your right, immediately adjacent to the small pumping station. Follow the track west until it opens out on to a number of farm buildings and a surfaced road. Turn right (8) along the road, noting West Kennet Long Barrow on your left hand horizon. Keep a look out also for the small groups of deer that can often be seen in the adjacent fields.

Just before reaching the bridge across the River Kennet take the signed footpath on your left (9). After a short distance, cross over the stile and continue onwards. To visit West Kennet Long Barrow (E), take the next well worn path on your left (10) which will take you directly there. Dating from around 3600BC, the barrow remained in use until about 2200BC, when it was finally sealed. Its first recorded excavation dates were from around 1685 and the last in 1955/6 when it was restored to something like its original appearance and what you see today. Many of the finds from the later excavations can be found on display in the Wiltshire Heritage Museum.

Those who decide not to visit the barrow (those who do should return to the main path and turn left) should continue onwards between the fence lines and then bear right through the kissing gate. Stay on the path as it crosses the infant River Kennet and head towards the A4. At the next kissing gate adjacent to the road, turn left briefly, where almost directly opposite you on the other side of the road is a gate (11). Cross the road with caution and proceed through the gate.

To your left stands the impressive Silbury Hill (F), which, at 30 metres high and 160 metres wide, is Europe's largest prehistoric man-made mound. Constructed largely from chalk in stages around 2500BC, its original purpose remains unknown, despite a number of theories and excavations. One surprising discovery, made during a BBC sponsored excavation in the 1960s, was a time capsule dating from 1849. Its contents included a poem written by William Wordsworth's cousin's daughter Emmeline

Fisher, the opening lines of which are included below. Continue along the well-worn path and pass through the next gate. The path then continues over two stiles and through another gate before reaching a small bridge across the Kennet. Those wishing to get closer to Silbury should turn left across the bridge (12), where the path leads to a small car park and viewing area. The return to Avebury is straight ahead through the gate, keeping the Kennet to your left. At the end of the path, go through the gate (13) adjacent to the A4361 and cross over. Head in towards Avebury briefly and then use the path on your left to arrive back at the car park (1).

'Bones of our wild forefathers O forgive,
If now we pierce the chambers of your rest,
And open your dark pillows to the eye.'

Lines suggested by the opening of Silbury Hill by Emmeline Fisher 1849.

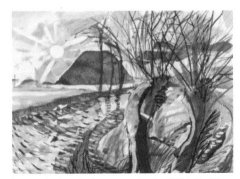

Silbury Hill Winter Landscape, mixed media 1997, by David Imms

13

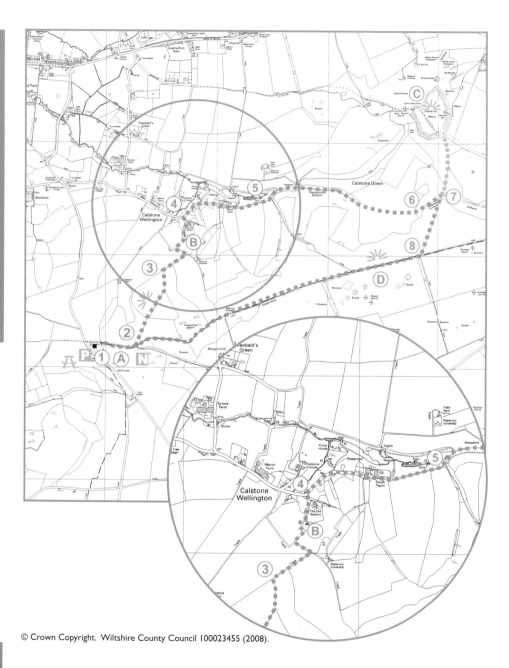

WALK 3

© Crown Copyright. Wiltshire County Council 100023455 (2008).

Morgans Hill: Walk 3

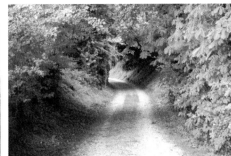
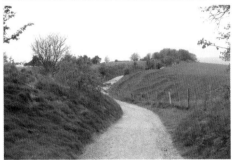

Distance: 4.6 miles

Minimum time: allow at least 2.5 hours

Stiles: 5

Terrain: unmade tracks & paths. Some minor road walking. One steep descent & one steep climb

From the car park at the Smallgrain plantation picnic site (1), proceed north east through the gap in the surrounding railings. Continue up the slope past the beech tree on your right, then down the steps on to the byway and turn right.

This section of the byway is where the original Roman Road was destroyed by the construction of Wansdyke (A), the remains of which stretch for 12 miles to Savernake Forest, just east of Marlborough. The origins of the dyke are unclear, but it is thought to have been built (though never finished) following the Roman withdrawal from Britain - and perhaps commenced prior to this - as a boundary and defensive line against some perceived threat from the north.

Stay on the byway until you reach the Wildlife Trust's information panel for its reserve on your right. The reserve is grazed by diminutive Dexter cattle and is home to butterflies such

as the Marbled White and Duke of Burgundy along with flowers including the pyramidal orchid, wild thyme and chalk milkwort. From the byway take a left turn through the gate (2) on to the bridleway, also waymarked as the White Horse Trail. Proceed downhill and continue straight ahead through two field gates. Stay on the path until you arrive at a third field gate adjacent to a chalk track (3). Turn right and follow the track until you reach a junction. Turn left here and continue until you see the waymarked field gate on your right. Proceed through the gate and then turn left through the next field gate. Once through this gate turn right and follow the fence line downhill, with the church of St Mary's ahead on your right (B). The present building dates from the 15th Cen-

tury and is notable for the extensive historical graffiti covering the walls of its porch and for a small yet attractive stained glass window.

Just past the church you will notice a stile on your right; cross this onto the gravel track, turn left and continue down the enclosed track until you come to the junction with the surfaced road (4). Turn right here and proceed until you come to a gate marked 'Private road to South Farm'. Keep going. At the next gate stay on the track marked 'Public Footpath' ensuring that you do not turn left down the bridleway. Continue along the track through the next wooden gate. Upon reaching the next metal gate, notice the direction of the waymarker on your right. The path you must follow is on your left (5) just before the bend in the track and goes downhill. At the bottom, climb over the stile and

continue to the field's edge and turn right. On the horizon ahead of you and standing within the Iron Age hillfort of Oldbury, is the Lansdowne Obelisk (C), erected by Lord Lansdowne in 1845 to commemorate his ancestor, the 17th century economist and inventor, Sir William Petty. Towering 125 feet above the hill, it is said to be the highest point between Bristol and London.

Following the field's edge, you will soon arrive at a National Trust sign marked 'Calstone Coombes' along with an adjacent stile. Climb over the stile and proceed straight ahead, cross over the next stile and keep going along the valley bottom using the well worn track. As you pass through the spectacular folds of the coombes you will notice what are generally considered to be medieval cultivation terraces or strip lynchets along the valley sides. Stay on this track as it bears to your left and in the distance on the top of the slope ahead you will see a stile (6). Proceed uphill across the stile and keep going. At the next field boundary (7) turn right keeping the field boundary to your left.

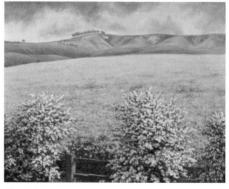

'Cherhill Down' by Nick Amey

Those wishing to visit the hillfort and obelisk and experience fantastic panoramic views should turn left. This will also give you the chance to view from above, the Cherhill White Horse carved into the hillside in 1780 by Dr Christopher Alsop, who used a megaphone to shout his instructions. In the late 1800s the horse's eye was filled with glass bottles so that it sparkled in the sunlight.

Upon reaching a set of metal gates (8) pass through and turn right on to the Roman Road adjacent to a belt of trees. This road originally stretched all the way from Bath, then known as Aquae Sulis, in the west to the Roman station of Cunetio, now Mildenhall, in the east. Interestingly the road is also aligned directly to Silbury Hill. Recent excavations here have discovered a Roman settlement of some size. In the field on your left (D) you will also notice a number of Bronze Age round barrows that make up part of a linear cemetery. Stay on this road as you make your way back to Morgan's Hill and the car park.

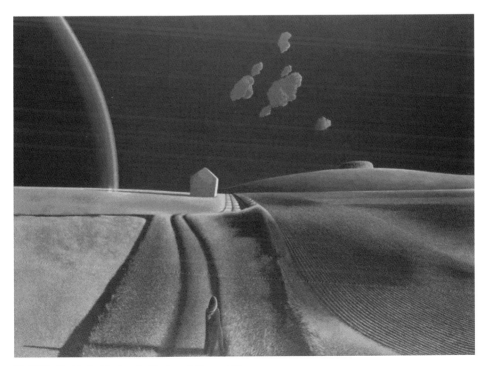

'She Did Not Turn' by David Inshaw (Looking towards Morgans Hill)

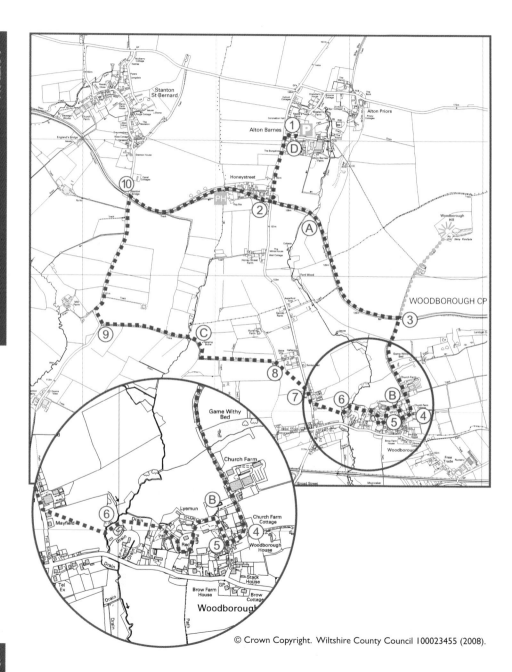

© Crown Copyright. Wiltshire County Council 100023455 (2008).

The Kennet & Avon Canal: Walk 4

Distance: 4.5 miles

Minimum time: allow at least 2.5 hours

Stiles: 6

Terrain: flat. Unmade tracks & paths (can get muddy). Some minor road walking.

From Rectory Close (1) in Alton Barnes (signed from the main road as 'St Mary Saxon Church') turn left onto the main road and head towards the tiny hamlet of Honeystreet. First recorded in 1773, it is generally believed that the name means 'sticky road'. Though rather peaceful today, there is plenty of evidence of its life as a busy industrial hamlet serving the Kennet & Avon Canal. Sadly the construction of the Great Western Railway in 1841, ensured that the canal, built only 30 years earlier, fell into long-term decline. Upon arriving at the canal, cross over the bridge and turn right immediately (2) down on to the towpath and turn right again. Continue under the bridge and along the towpath. Passing under the next bridge you will soon come to a sign on your right marked 'Memorial' (A). A short walk across the adjacent field leads you to a stone commemorating the two crew members of an Albermarle bomber who lost their lives when it crashed nearby in October 1944.

Back on the towpath, continue towards the next bridge noting the unmistakable tree-covered peak of Woodborough Hill on your left. On reaching the bridge leave the towpath and pass through the gate at the top of the short slope on your right (**3**).

From here you can either turn right and continue the walk or turn left and head up to Woodborough Hill. The walk to its summit takes about 15 minutes and includes a rather steep climb, but the views are stunning and it makes

a perfect spot for a picnic. Turning right you head towards the village of Woodborough. Stay on the track until you arrive at the five bar metal gate. Pass through to the side of the gate and continue onwards past Church Farm, whose house dates from the 18th century. Once through the farmyard you will soon arrive at a junction (**4**). Turn right here along the road to the next junction (**5**) where you turn right again and head towards the village church (**B**). What you see today is a Victorian church in the churchyard of an earlier medieval building. Its

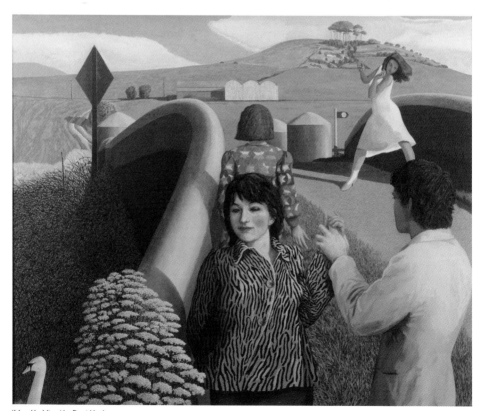

'Hand holding' by David Inshaw

most notable graves are those of the Stratton family, a local farming dynasty which at one point controlled the largest acreage of farming land in all of England. From the church continue along the road as it bears left, following the signed footpath. Stay on this path as it continues along the right hand side of a thatched cottage and becomes a grassed track. Pass through the kissing gate and continue straight ahead. Climb over the next stile and head for another kissing gate. From here proceed towards the yellow marker post just in front of the trees (6).

Continue through the trees keeping the stream to your right before crossing it, using a small footbridge, which you must climb onto, to reach the adjacent field. From here cross the field heading for the barn to the right of the bungalow ahead of you. Upon reaching the barn cross over the adjacent stile and continue to the main road. At the road turn right and then cross over almost immediately and follow the signed footpath (7) across the stile and diagonally through the field (8). Upon reaching the field edge cross over the stile and down several steps onto the Bridleway and turn left. Shortly after the track bends quite sharply to the right, look out in the adjacent field for the Hanging Stone (C). Legend has it that a thief placed a stolen sheep upon the stone whilst having a rest. Unfortunately the sheep fell off and the rope to which it was attached caught around the thief's neck, thus hanging him.

Stay on the track until you come to a junction at which you turn right (9). Continue along this road which will soon bear right and head north

towards the village of Stanton St Bernard. Ahead of you on the horizon, just to your right, is the Alton Barnes White Horse carved in 1812 at the request of Robert Pile the tenant of Manor Farm. He commissioned a local journeyman John Thorne, known also as Jack the Painter, to supervise its cutting, but Thorne fled with his fee of £20, leaving Pile to complete the work.

Upon reaching the bridge (10) across the canal, take a left through the gate and down on to the towpath. Turn right under the bridge and stay on the path until you reach the Barge Inn, ideal for refreshments and also an international centre for crop circle enthusiasts. From here continue up to the next bridge (2) where you take a right back up onto the main road. Turn left, back over the bridge and stay on the road back to the start. As you near Rectory Close don't miss out on the small yet engaging Alton Photographic Museum (D), in the garage of the house named 'Raymar' on your right.

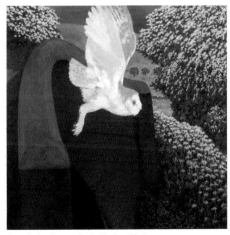

'Barn Owl at Stanton Bridge' by David Inshaw

Visitor Information

Public Transport

Trains - Tel: 08457 484950 or visit www.nationalrail.co.uk

Buses - Tel: 0870 6082608 or visit www.traveline.org.uk

Buses to the Kennet & Avon Canal - Tel:01249 460600 or visit www.wigglybus.com

Coaches - Tel: 08705 808080 or visit www.nationalexpress.com

Local Tourist Information Centres

Avebury - Tel: 01672 539425

Devizes - Tel: 01380 729408

Marlborough - Tel: 01672 515190

Swindon - Tel: 01793 530328/466454

Useful Websites

Wiltshire Tourism - www.wiltshiretourism.co.uk

North Wessex Downs AONB - www.northwessexdowns.org.uk

Wiltshire Heritage Museum - www.wiltshireheritage.org.uk

The Richard Jefferies Society - http://richardjefferiessociety.blogspot.com

The Ridgeway National Trail - www.nationaltrail.co.uk/Ridgeway/

The National Trust - www.nationaltrust.org.uk

English Heritage - www.english-heritage.org.uk

The Kennet & Avon Canal - www.visitkanda.com

The work of David Inshaw - www.tabretts.co.uk

Countryside Access Charter

Your Public Rights of Way are:

Footpaths - On foot only. These are waymarked in yellow.

Bridleways - On foot, horseback and pedal cycle. These are waymarked in blue.

Byways - Open to all traffic. These are waymarked in red.

Restricted Byways - On foot, horseback or leading a horse. In vehicles (not mechanically propelled).

On Public Rights of Way you can:

* Take a pram, pushchair or wheelchair if practicable.

* Take a dog (on a lead or under close control).

* Take a short diversion around an illegal obstruction or remove it sufficiently to get past.

The Countryside Code:

* Be safe, plan ahead and follow any signs.

* Leave gates and property as you find them.

* Protect plants and animals and take your litter home.

* Keep dogs under close control.

* Consider other people.

For your information

All walks in this publication use the Public Rights of Way network, which is maintained by both Wiltshire County Council (Walks 1, 2, 3 & 4) and Swindon Borough Council (Walk 1 - part).

Both authorities have a duty to protect & maintain the network and any problems encountered on them should be reported to:

Wiltshire County Council - Tel: 01225 713875 or Email: rightofway@wiltshire.gov.uk

Swindon Borough Council - Tel: 01793 463725 or Email: customerservices@swindon.gov.uk

Further Reading

J R L Anderson & Fay Godwin. *The Oldest Road: An exploration of the Ridgeway* (Wildwood 1975)

Aubrey Burl. *Prehistoric Avebury* (Yale University Press 1979)

John Chandler. *The Vale of Pewsey* (Ex Libris Press 1991)

 Devizes & Central Wiltshire (Ex Libris Press 2003)

Julian Cope. *The Modern Antiquarian* (Thorsons 1998)

Paul Devereux. *Symbolic Landscapes* (Gothic Image 1992)

W H Hudson. *A Shepherd's Life* (Methuen & Co 1910)

Richard Ingrams. *The Ridgeway: Europe's Oldest Road* (Phaidon 1988)

Richard Jefferies. *Wildlife in a Southern Country* (Smith,Elder 1879)

 The Story of my Heart: My Autobiography (Longmans, Green 1883)

Stuart Piggott. *William Stukeley: An Eighteenth-Century Antiquary* (Clarendon Press 1950)

Christopher Martin. *The Ruralists* (Academy Editions 1991)

Neil Mortimer. *Stukely Illustrated* (Green Magic 2003)

Lynda J Murray. *A Zest for Life: The story of Alexander Keiller* (Morven Books 1999)

Mike Pitts. *Hengeworld* (Century 2000)

Charles Hamilton Sorley. *Collected Poems* (Cecil Woolf 1985)

Edward Thomas. Everyman's Poetry Series (Everyman Paperbacks 1997)

 Richard Jefferies (Hutchinson 1909)

Kenneth Watts. *The Marlborough Downs* (Ex Libris Press 1993)

Alfred Williams. *Villages of the White Horse* (Duckworth & Co 1913)

 Life in a Railway Factory (Duckworth & Co 1915)